Flowers in Pastel

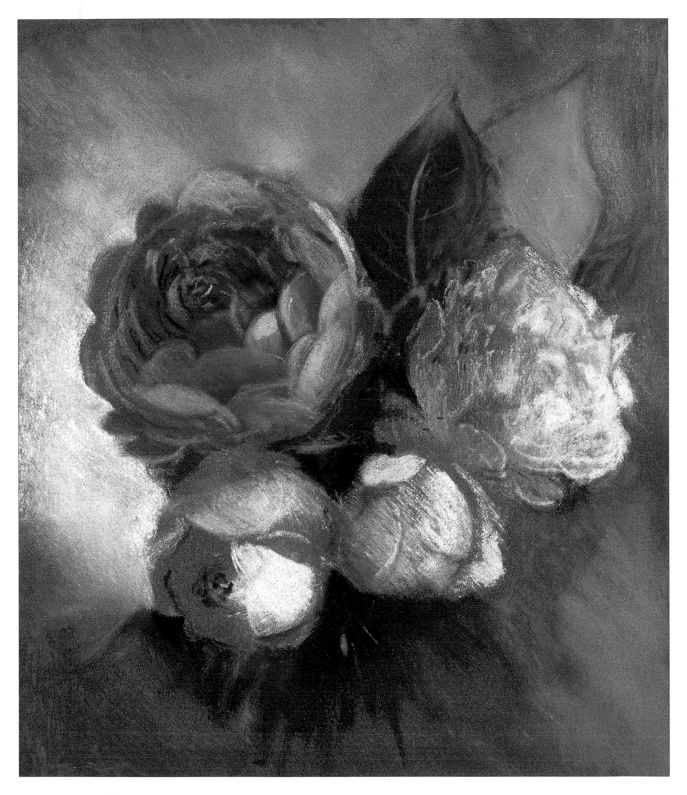

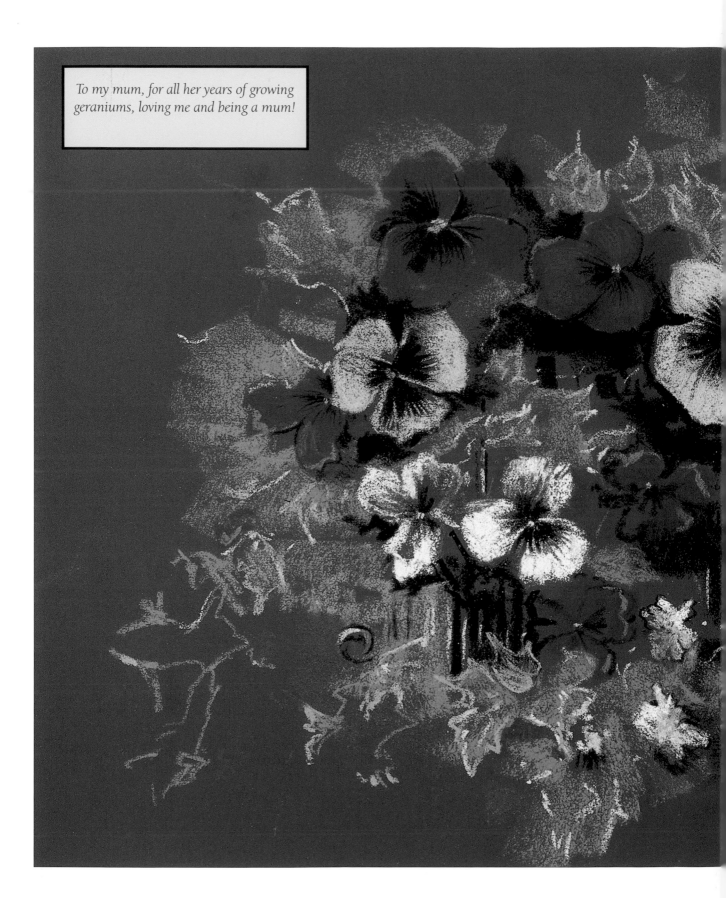

To my mum, for all her years of growing geraniums, loving me and being a mum!

Flowers in Pastel

MARGARET EVANS

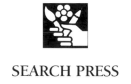

SEARCH PRESS

First published in Great Britain 2002

Search Press Limited
Wellwood, North Farm Road, Tunbridge Wells, Kent TN2 3DR

Reprinted 2003, 2005, 2007 (twice), 2008, 2009

ISBN: 978 0 85532 851 1

The publishers and author can accept no responsibility for any consequences arising from the information, advice or instructions given in this publication.

Suppliers

If you have difficulty obtaining any of the materials and equipment mentioned in this book, please visit our website at www.searchpress.com. Alternatively, write to the Publishers at the address above for a current list of stockists, including firms which operate a mail-order service.

Publisher's note

All the step-by-step photographs in this book feature the author, Margaret Evans, demonstrating how to draw flowers with pastels. No models have been used.

Printed in Malaysia

Many thanks to all my lovely students for filling our gardens with flowers and friendship; especially remembering Yvonne. Thanks to the Famiglia Simoncini for their Tuscan inspirations, and to Roz and Ally at Search Press for their support and help in making this book. Most of all, special thanks to Malcolm, Matthew and Melissa for always being there and believing in me, and occasionally buying me flowers!

Cover

Blue Poppies

The red textured card I used for this composition shows through in places to provide a strong contrast.

Size: 250 x 290mm (9¾ x 11½ in)

Page 1

Constance Spry Roses

I preferred the softer surface of pastel card to create the delicacy of these roses, and chose the glowing red paper to emphasise the numerous warm tints these roses reflect. The fullness of the Constance Spry rose was carefully built up with layers of pastel, in shades of light and dark pink, which meant that less detail was needed for the other roses.

Size: 280 x 230mm (11 x 9in)

Pages 2–3

Pansies

The bright colours make pansies an extremely striking flower, so I used a dark paper to help the flowers project from the page, and let the foliage disperse into the blue shadows. The pastels were used dry.

Size: 290 x 350mm (11½ x 13¾ in)

Opposite;

Mother's Day Bouquet

The benefit of buying an artist flowers is that they last forever! I wanted to make the cool blues and greens really stand out against the rich, warm, peach colours of the flowers, so I chose pale paper which would not compete with them, and which also enhanced the delicacy of the subject. The pastels were used dry.

Size: 410 x 210mm (16¼ x 8¼ in)

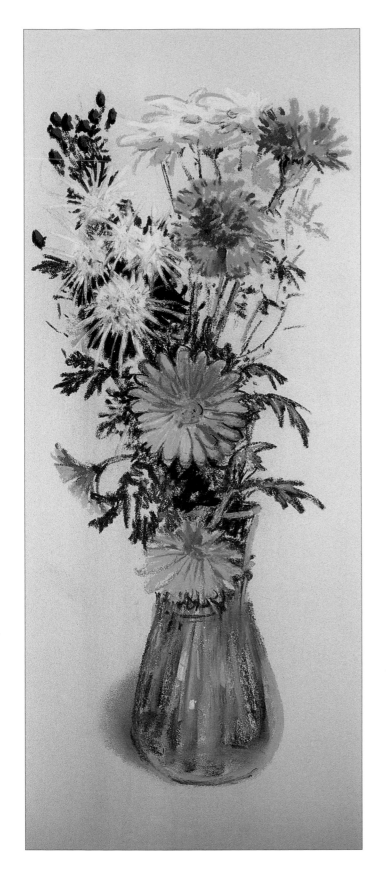

Contents

Introduction

This book is written for those who want to paint the 'suggestion' of flowers, not an accurate botanical illustration. Whatever subject I paint, I strive to give an impression, rather than the actual detail, and I relish a painting which leaves something to the imagination.

This loose style can be achieved either with pure pastel, or with pastel which has been under-painted with various media, including watercolour, acrylic and gouache. Pastel comes in so many forms that my aim is to inspire you with the ideas in this book, not to suggest that you copy them. For the best results, you should be willing to improvise and experiment, allowing your own personal expression to develop. Try adding water to your pastels to find out whether they are soluble; some are, and some resist water, which is in itself an interesting effect. Try diluting your pastels with turpentine to see if they react, and enjoy the surprises that result. There will be some happy accidents; other experiments will fail – but you will at least have learned something.

Pastel is such an expressive medium, with its ability to capture the essence of the subject and its huge range of delicious colours and tints, which are particularly suited to flower painting. Although I teach the use of a limited palette for painting, these principles are abandoned when I come to paint flowers. Then, I have the opportunity to use all those wonderful colours which seem too loud, too extravagant and too vibrant to use for other subjects.

I tend to simplify the painting I am doing into three simple stages: sketching in; blocking in and building up. I then allow myself what I call a 'five-minute fiddle' to put in any little details that are urgently lacking. At this stage, the painting is unofficially finished, by which I mean that it needs to sit on a 'simmering' shelf and be looked at in passing. If, after a few days, nothing leaps out at me as being glaringly wrong or missing, the painting is declared finished and is duly signed.

This process may help to keep you on the straight and narrow, but do not resist good, old-fashioned impulse and inspiration. If something grabs your attention just go for it, whether it is a field of poppies you have stumbled upon, or an intricate rose which simply takes your breath away.

I do not apologise for the number of roses that appear in this book. There are more than 120 different species in my garden and every one inspires me. I hope you enjoy them too.

Margaret Evans

Irises

I sketched in the shapes of the main flowers lightly, then blocked in with strong, rich purple, surrounding the area with light creams and pinks to create a strong contrast on the dark-toned paper. This light and dark effect gave the appearance of sunlight and shadow on the subject and needed no further building up or blending. The main iris was then developed using hard pastel sticks to apply detail over the softer, richer pastels. Note how thinly the pastel is applied on the bottom iris which is just appearing from the shadows, in comparison with the richer impasto effect of the thick colours on the top blooms.

Size: 455 x 255mm (16 x 10in)

Materials

Pastels come in so many shapes and forms, hard and soft, that what we invariably do at first is try to keep them neatly in separate boxes according to type. This is the reason some people say that pastels are too bulky to travel with – but it is not true! I have various boxes of all sizes, each filled with a mixture of hard and soft pastels in all colours. All of them are broken, with their papers removed so I can block in colour using the side of the sticks.

My largest box (see photograph below) is known as my studio box, though it is compact enough for travelling. It has compartments into which I sort pastels according to colour and tone. The ideal box has enough sections for light, medium and dark shades of each main colour. This box also has a long compartment which is useful for pencils, torchons, knives etc. I have another box, similar in style but half the size, which I use for travelling abroad. This is padded top and bottom with foam to prevent the pastels moving and rattling around in transit.

Drawing board This should be smooth and free from bumps or indentations. I use a wooden board in the studio, and a lightweight foam board when travelling. I always work on top of several layers of paper for extra protection.

Craft knife Use this for sharpening pencils. I never sharpen pastels – what a waste!

Masking tape Use this to stop paper edges flapping in the wind, and to mask off sections of a paper sheet when sketching several scenes on one sheet.

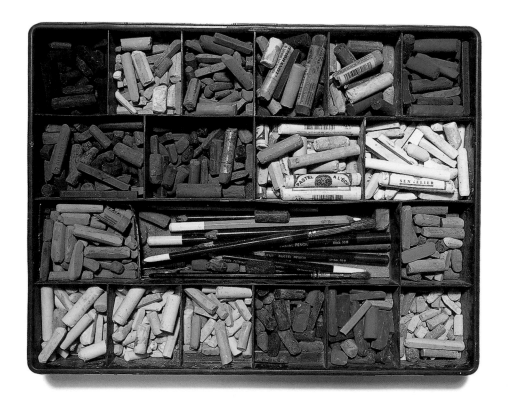

Pastels My pastels range from extremely soft to the hard crayon types. Some find these pastels too hard, but they are invaluable for creating detail, and give better control, especially for fine details on smaller-scale work. They are also excellent for travelling and outdoor work, as they do not crumble as easily as softer brands. I think that every box should include a selection, but I take care not to overuse them – otherwise there is a tendency to 'fiddle'!

Rag This is useful for taking excess pastel dust off my fingers.

Eraser I prefer to use a putty eraser.

Torchons or blenders I sometimes use these to merge pastels, thus avoiding the need to rub them with my fingers, which can make the result very muddy.

Brushes To apply water to pastel, I use synthetic round watercolour brushes (Nos. 6 and 10) and a flat 2.5cm (1in) brush. The round brushes are great for more directional application, and are used with 'wet' water for diluting colour, or with 'damp' water (see page 38) for intensifying colour. The flat brush is ideal for wetting a large area of pastel to create a broad mass of colour. I keep them separate from my other brushes – some of the abrasive papers I use would spoil my good watercolour brushes. I also use old bristle brushes for scrubbing off mistakes, or when the tooth of the paper is overloaded with pastel and I want to add more layers. Other 'scumble' brushes and fans are useful simply for scrubbing off pastel.

Water pot A collapsible water pot is handy when diluting pastels with water.

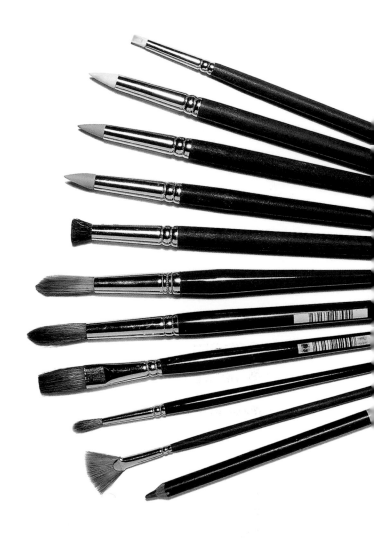

A selection of blenders, brushes and a graphite pencil

Pencils For quick sketching, I sometimes carry a pencil case with pastel pencils and a few soft graphite pencils. I sharpen pastel pencils with a craft knife, but not to a point – I just expose enough of the pastel core to work with, then use the pencil on its side to wear it down to a point.

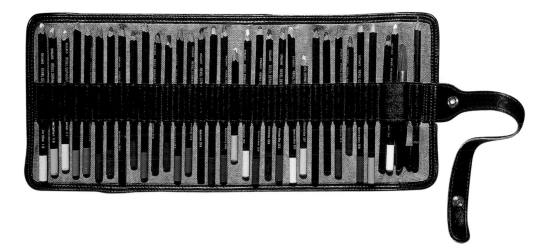

My pencil case

Paper

Paper choice is one of the most important decisions I make before starting any pastel painting. The effects created by different textures and colours of papers can have an enormous effect on the finished work; choosing wisely can turn an otherwise dull subject into a vibrant painting. I prefer dark or bright colours, as they add vibrancy to the subject and cast wonderful lights through the painting.

For serious painting, I prefer heavier weight papers or boards. These come in qualities ranging from smooth and velvety to those with an abrasive texture – or even sandpaper. Smoother papers are ideal for portraits, but I use them only for sketching. If my subject needs a lot of building up, perhaps for complicated or textured subjects, I choose a rougher surface. Papers which combine an abrasive texture with a good range of colours are readily available.

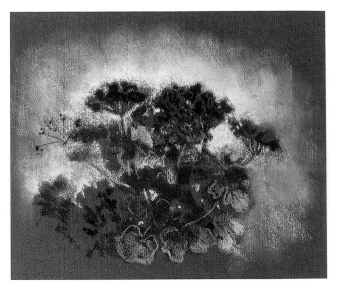

Geraniums

I used thin pastel paper with surface texture for these geraniums: it is fine if you do not intend to build up too many layers. The dark paper intensifies the dark appearance of the flowers against the sunlight, and the background is lit with pale lemon.

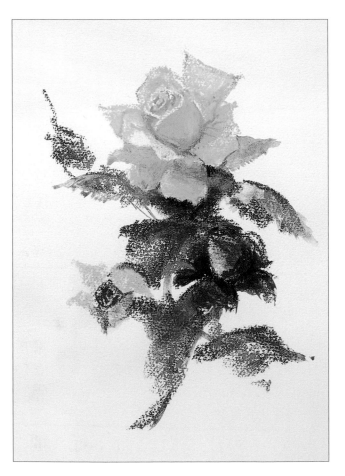

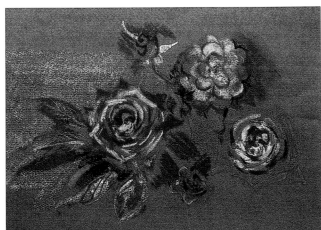

Pastel paper

The rose heads (above) were applied to abrasive pastel paper using thick pastel and built up by adding stronger colour. In some areas, the colours were rubbed with a finger or a shaper to blend them and provide a smooth contrast with the rough texture of the paper.

Watercolour paper

The subject (left), and the way the pastels are applied is similar, but the different texture of the paper gives the foliage a rugged quality. The delicate texture of the flowers is created by building up washes of colour by dampening pastel layers with a brush.

Choosing paper colour

I always advise beginners, who may feel a bit bewildered, to choose warm-coloured paper for cold subjects like snow scenes, and cool-coloured paper for warm scenes including portraits. Another hint is to choose paper in a colour complementary to the picture's colour theme: for a predominantly orange subject like lilies or marigolds, purple paper is ideal; a subject with dominant green foliage looks vibrant with red paper; red flowers like geraniums look stunning against green. Once confidence builds up, I start to 'break' these rules, and experiment with white papers for white flowers etc., just to challenge the painting skills and create different effects.

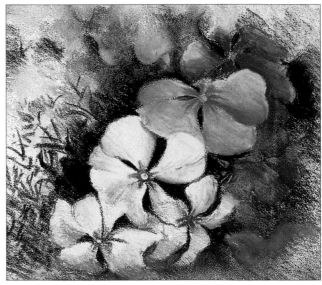

Indian pinks
These pink and white flowers were so vibrant against the dark green foliage that I chose light paper (cream) to highlight them. Pale papers give a clarity and purity to pale or white flowers. The base colours were blocked in lightly with fairly hard pastels, as I wanted to build up detail with pastel pencil. Soft pencils clog up the tooth of the paper, making it more difficult for the pencil to adhere.

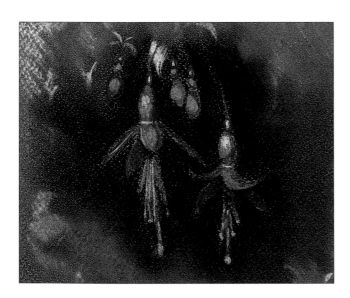

Fuchsia
Using bright red paper and surrounding the fuchsia flowers with dark shades helps to emphasise their brilliance. I often choose a paper colour which closely matches the flower, then work by 'cancelling out' everything else.

Paper
One of the most exciting aspects of pastel painting is choosing the paper colour, and watching how it reacts with the colours you use. If you plan to add water or paint to the pastel, it is important to be aware which papers are compatible with water, regardless of texture or colour.

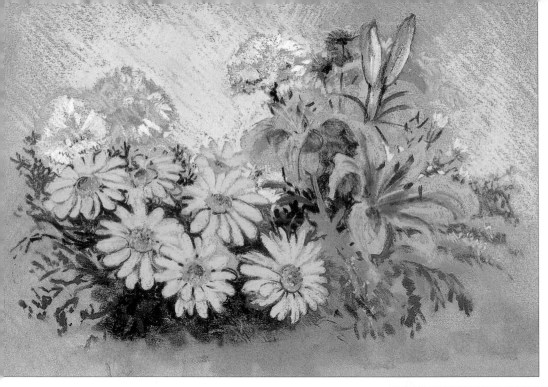

Neutral background

The flowers in this bouquet are predominantly yellow, and in places they almost merge with the warm yellow background. Transparent paper was ideal for the soft edges I wanted to create. The yellow daisies were built up with thick pastel to contrast with the strong dark foliage; surrounding flowers were kept subtle by merging the colours into the background.

Size: 250 x 360mm (9¾ x 14¼ in)

Transparent paper

Working on transparent paper is an unusual way to produce spectacular effects in your pastel paintings. The paper provides a neutral background for your work, and it is only when you have finished that the fun really begins! Slide papers in different colours under the transparent paper, and see how they enhance different sections of the painting.

Blue paper

This casts a cool glow over the painting and breaks up the spaces between the flowers, creating maximum contrast with the greens and yellows.

Red paper

This adds a warm pink glow over the painting, and helps to merge the shadows into the flowers in places, giving an altogether softer appearance.

Purple paper

Purple is a direct complementary of yellow, and changes the appearance of the bouquet, again softening the mood of the subject.

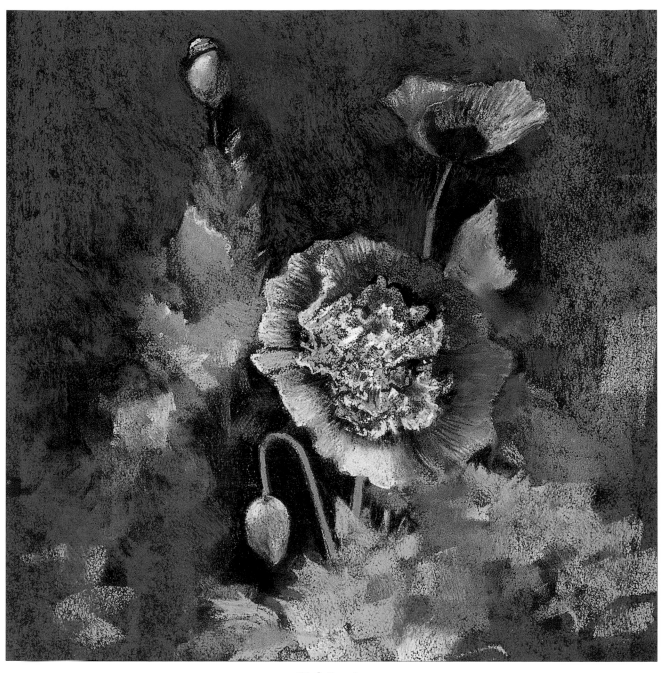

Pink Poppies

Rich, dark burgundy red paper emphasises the pale pink papery poppies and contrasts with the cool grey-green foliage. The main bloom and buds were built up by sketching in the outer shapes carefully, blocking in and building up the detail. The foliage was left loose and unfinished after blocking in, to create the illusion of movement and avoid competition with the flower heads.

Size: 330 x 305mm (13 x 12in)

Colour choice

The process of choosing colours is closely linked to choosing paper. Paper colour choice determines the mood and impact of the painting, so the pastel colours used to paint the subject need to be clear, vibrant and un-muddied.

With any painting medium, the reason for limiting the palette is to avoid mixing mud. Too many colours will not only look busy and fragmented, but will make muddy mixtures. The same is true of pastels: with flower painting, in particular, it is essential to keep the colours as pure as possible, to try to emulate the purity of nature's colours. I teach my students to try to limit the number of colours in any one painting to about twelve, give or take one or two. This allows for sufficient colour selections for the main subjects, as well as tonal modifications such as lights and darks in warm and cool options.

If you are buying pastels individually to start a set, I recommend seven basic colours: two yellows, two reds, two blues and a brown (below), from which you can mix virtually anything. Extra colours can be added as your skill develops.

Basic palette

These seven colours will allow the beginner to mix virtually any shade: lemon yellow; raw sienna; burnt umber; crimson; light red; ultramarine; Prussian blue.

Palette 2: extra tints and colours

These ten tints and colours are a natural extension of the basic palette, and would be good for a beginner: burnt sienna; pale orange; portrait pink; Naples yellow; cadmium yellow; ochre; sap green; purple grey; rose madder; sky blue.

Palette 3: shadow tones.

These six dark tones are ideal for creating depth: dark green; indigo; dark grey; blue grey; dark red and another dark brown. Manufacturers' names are not important by this stage; this range of dark tones will add depth to the subject in either warm or cool situations.

Matching pastels and paper

I often contrast the paper strongly with the subject, by choosing a complementary colour: one which is opposite in the colour spectrum, for example red paper with a predominantly green subject, or purple paper to contrast with an orange flower.

Sometimes, a certain colour paper will seem ideal for a subject, perhaps for its similarities rather than because it is a complementary or contrasting colour. It can be inspiring to work on similar-coloured paper, but I am always aware of the need to build complementary colours into a painting so that the result is not too flat. This is not an exact science, in that these complementary colours need not be technically opposite each other on a colour wheel, but each picture should have the appropriate balance of light and dark tones, and warm and cool areas.

The more practice you have with different paper colours and textures, the more confidence you will gain. In time, you will see how the subtleties of paper colour – whether you choose to match or complement your subject – can add an extra dimension to your work.

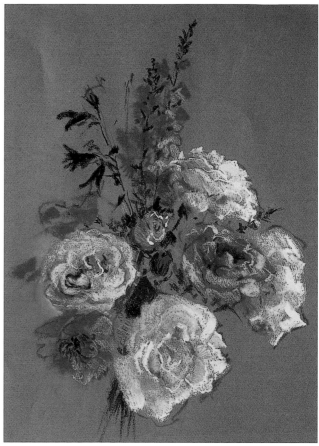

Roses

The purple paper in this example almost matches some of the colours in the roses. I sketched in the outlines of the flowers with a mid-toned pink, then blocked in with appropriate colours, using the main colour of one flower to highlight or shadow others. This limits the colours in the palette, and helps to blend the composition. The green foliage has minimal detail and simply uses one dark, neutral green to pull the flower shapes together.

Size: 250 x 380 (9¾ x 15in)

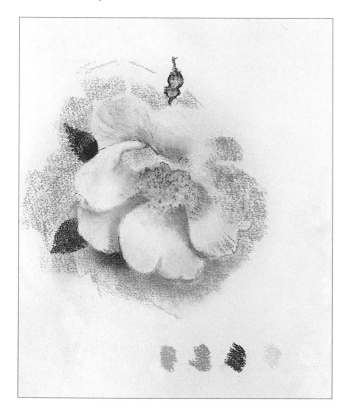

Frühlingsgold rose

An extremely delicate flower is portrayed using a limited palette of five colours, which are added in layers and dampened with water to create subtle washes. The background texture is simply dry pastel on the paper surface.

Playing with pastels

With any new medium, it is fun to get to know it better and to experiment. The first thing to do with pastels is to take the papers off and break them! I know this seems drastic, and you may not want to spoil your nice new box of pastels, but you cannot use them to full advantage when they are neatly wrapped in paper.

A pastel in full-length stick form is simply a drawing tool, as the only part exposed to work with is the tip. This is an acceptable way to work with pastels, but if you break off about a third of the stick, and take the paper off, it becomes an entirely new medium – the equivalent of a one- or two-inch brush stroke! If you hold the pastel stick on its side and pull it across the paper you immediately make a 'painterly' mark, otherwise known as 'blocking in'. If you make the same mark with a much lighter touch, it becomes 'glazing', a technique in which one colour can be dragged over another to create a colour mix. All these techniques allow you to cover paper, to cover larger areas, and in conjunction with the marks made with the edge of the stick, to develop drawing and painting skills.

Pastels can be turned into paint by adding water, either with a wet brush which dilutes the colour, or with a damp brush, which intensifies the colour by making it solid. Remember that pastel is simply pure pigment, and water applied with a brush turns it into pure colour, an effect which is mouthwatering to watch! For more information on adding water, see *Adding Water*, page 38.

Making marks

Use the edge of the pastel stick to draw lines, and hold it flat against the paper to block in colour.

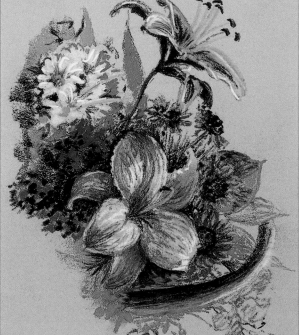

Cleaning pastels

I always carry a small plastic tub, half filled with ground rice. If my pastels look dirty, I simply drop them into the ground rice, close the lid and shake. The pastels come out looking as good as new.

Lily basket

A potentially-complicated basket of flowers is simplified by taking just a section of the group to portray their colour. The pink-grey paper blends with the predominant flower colours to help to 'melt' the edge of the composition, and the number of shades of green used is kept to a minimum to complement the brightness of the flowers. The larger flowers are built up with several layers of dry pastel, as opposed to the surrounding flowers which are sketched in boldly then left as suggestions.

Size: 210 x 250mm (8¼ x 9¾ in)

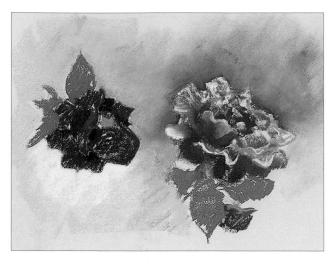

Roses

Bolder strokes with no preliminary drawing gives an immediate effect of big, blowsy roses, with directional strokes to show the angles made by the petals.

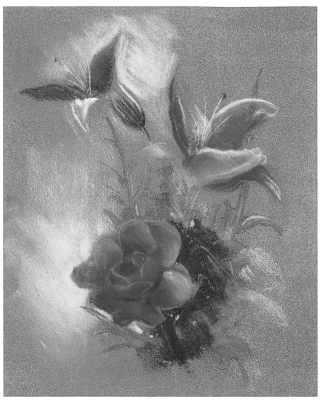

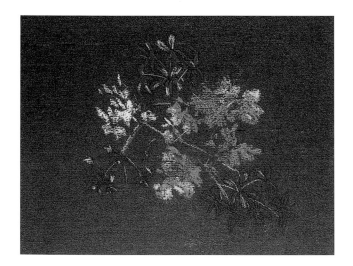

Geraniums

Simple marks made in different directions are enough to suggest the flimsiness of these geranium heads, with light smudges of green to suggest foliage without detail.

Roses and lilies

This quick demonstration shows how drawing in the outline of a particular flower, then filling in with colour and detail, suits some structured species best.

Amalfi bougainvillea

This demonstration showed a group of students on a trip to Italy how to capture a complicated flower quickly. Bougainvillea was everywhere, cascading down buildings, steps and railings. This impression was created by blocking in shapes using the side of pastel sticks in varying colours, overlapping in places, then a touch of foliage detail with the edge of the stick, and a few dots of colour for the final touches.

Size: 260 x 280mm (10¼ x 11in)

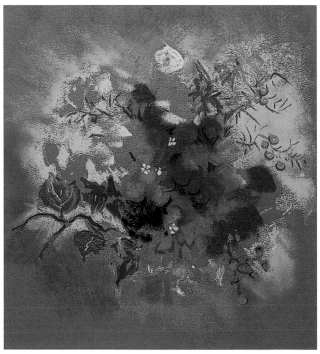

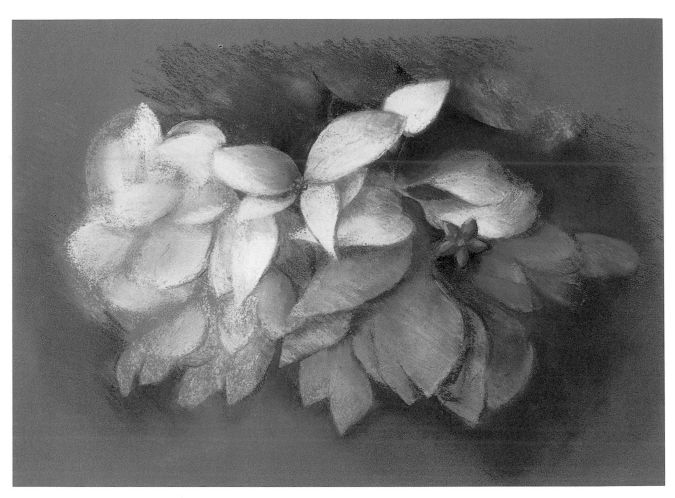

Indian bloom

This exquisite flower, similar to a poinsettia, caught my eye in
a hotel garden in India: its tiny, delicate flower was so strong
against the white bracts. Sometimes the delicacy of flowers
inspires you to work in greater detail, and I enjoyed the process
of developing the intricacies of this small exotic marvel.

Size: 200 x 300mm (7¾ x 11¼ in)

Astilbes

Sometimes the paper colour inspires me
first, as in this case where I had a bright
turquoise paper and wanted a subject that
would really vibrate against it. The perfect
partner was the bright red of the astilbes,
which I blocked in solidly to cover areas
of turquoise, otherwise the paper would
overtake or 'swamp' the subject.

Size: 290 x 250mm (13 x 9¾ in)

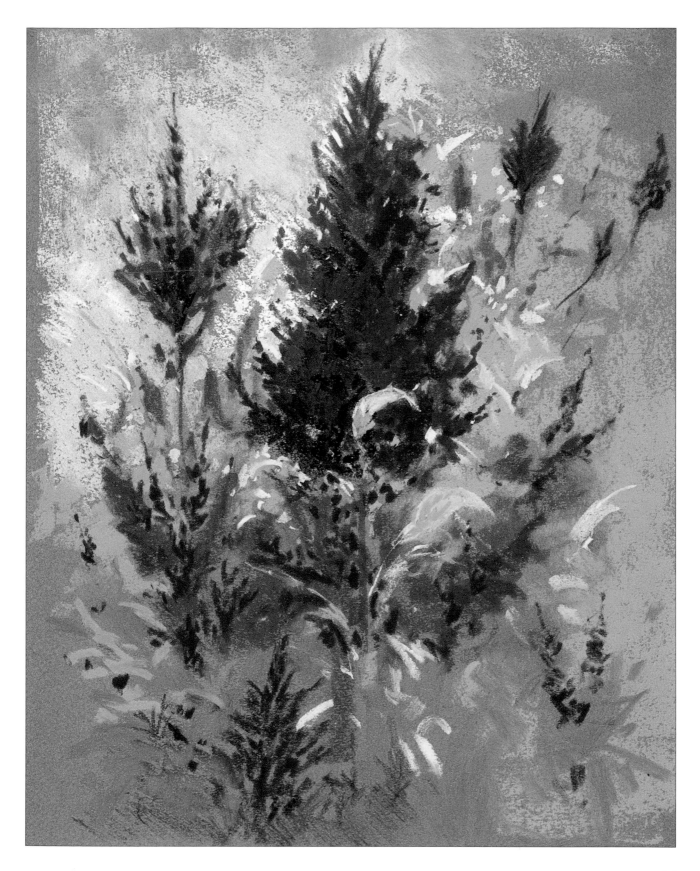

Potted plants

Colourful potted plants are a good subject for your first attempt at a flower picture. The plants are easily moved around until you are satisfied with the arrangement, and there is no need to worry too much about the actual pots as they will fade into the background.

I have chosen green paper for this composition, in a shade which roughly represents the central register of green tones. I plan to focus on the central area with the detail fading out and becoming less important towards the edges. I am not looking for contrast; the colour of the blooms is more important than that of the foliage, which will just be a suggestion. I usually integrate a shade of pastel which matches the paper into my palette, and work it into the painting to pull all the elements together. For the same reason, I make sure that each main colour used is repeated as an accent in another area of the picture.

It is a good idea to make a preliminary sketch on cartridge paper, just putting in the main outlines of the arrangement with a very soft pencil. I clip this to the side of the easel as a reminder, so I can just move my eyes to look at it rather than having to peer round the side of the easel every time.

You will need
Potted plants
White cartridge paper
Soft pencil - 8B
Green paper
Pastels
Dry duster or tissue

Tip
Don't be too particular about matching colours to the pastels as you can always match straight on the paper.

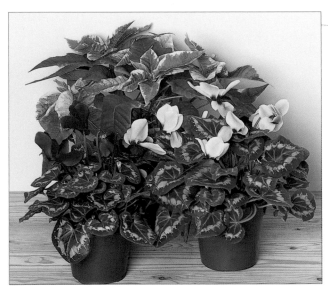

The plants I used
Whether you paint from life or use a photograph, work out where the lights and darks fall before you start your preliminary sketch. Remember that this does not have to be a slavish representation of your source material – you can add more flowers and vary the colours as you like.

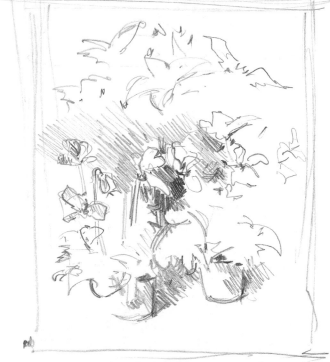

1. Working freehand, sketch in a rectangle on white cartridge paper. Make a preliminary sketch of your plants, putting in just the main marks and using a very soft pencil – 8B is ideal.

Use a small dish or a polystyrene tray to hold the pastels for a painting as you work.

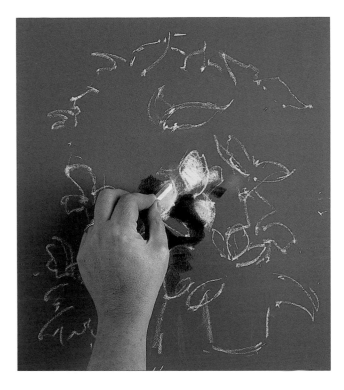

2. Put in a rough guide in white pastel, working in from the outside to make sure the composition fits on the paper. Suggest the darkest and lightest areas in black and white — I call it 'putting in the oomph early'. Remove any loose pigment with a dry duster.

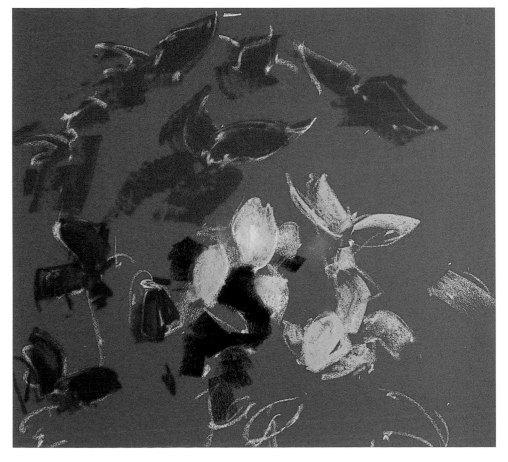

Tip
Do not give up on your painting just as it is becoming interesting. Pastel is very forgiving: it is easy to adjust or deepen colours at any time, if you are not happy with the effect.

3. Block in the main colours of the flowers, picking the different pastels by eye and keeping them in a small dish so you can pick them up again easily.

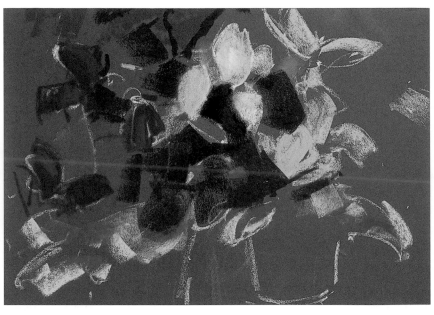

4. Add the green tones, adjusting them until the balance is right, and remembering that the paper represents the mid-tones. Pick out the flower shapes in dark green.

5. The foliage should be cool to contrast with the hot pink flowers, so add blue to tone it down where necessary.

6. Work over the whole area of your picture, making sure the main areas of colour are correct.

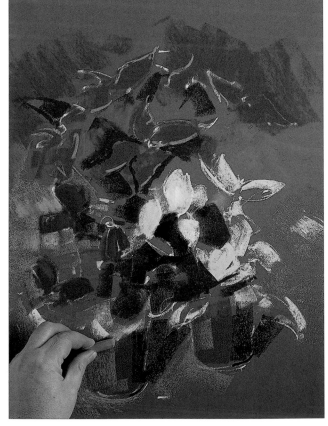

7. Create atmosphere around the subject using tones from your palette. Block in the pots, incorporating some of the flower tones to link the different elements of the picture.

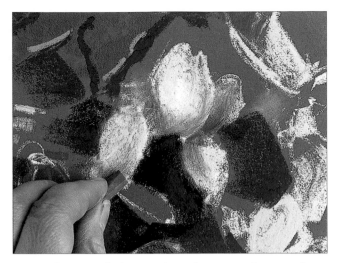

8. With a very light touch and using a deep pink pastel, add detail to the pale cyclamen in the centre of the picture.

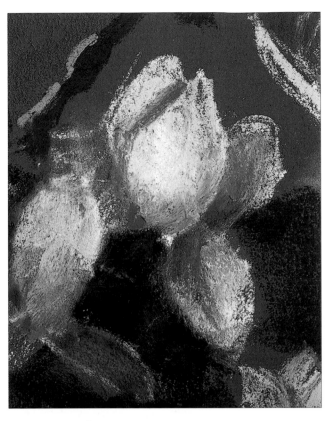

9. Create shadow on and around the blooms with the blue that was previously used to tone down the lower foliage.

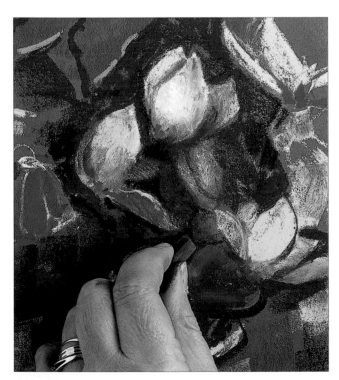

10. Build up the detail around the flower to make it appear to stand off the paper.

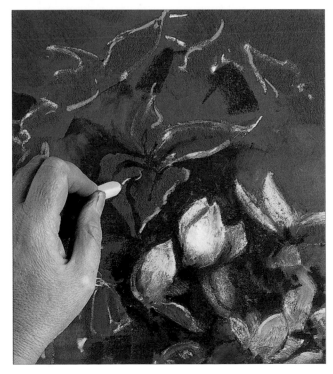

11. With light cream, put in the detail of the poinsettias in the central area of the painting.

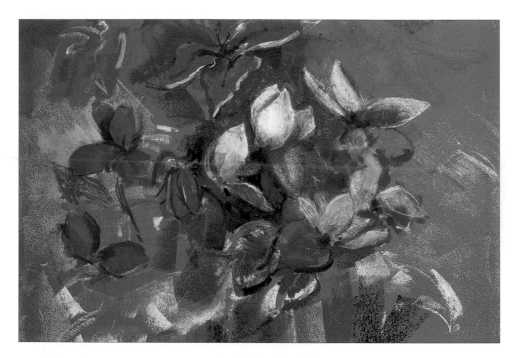

12. With dark green and blue, work on defining the leaves of the plants.

13. Go back to the outside of the picture and work over it to soften the details, rubbing gently with your fingertips in places to merge the pastels.

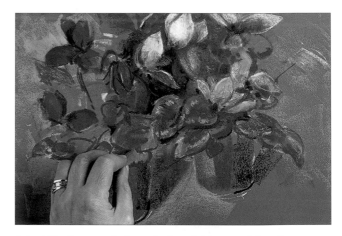

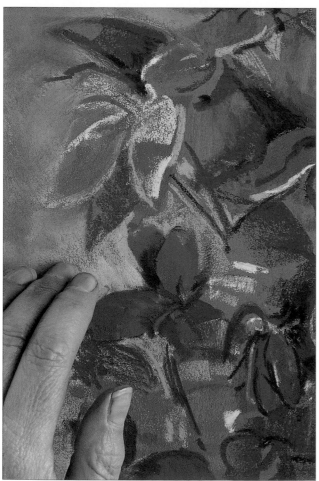

14. Work round the whole of the outside of your picture in the same way. Take a good look at the composition as a whole and work over it, tidying up details and adding touches of pastel if necessary.

Opposite: the finished painting

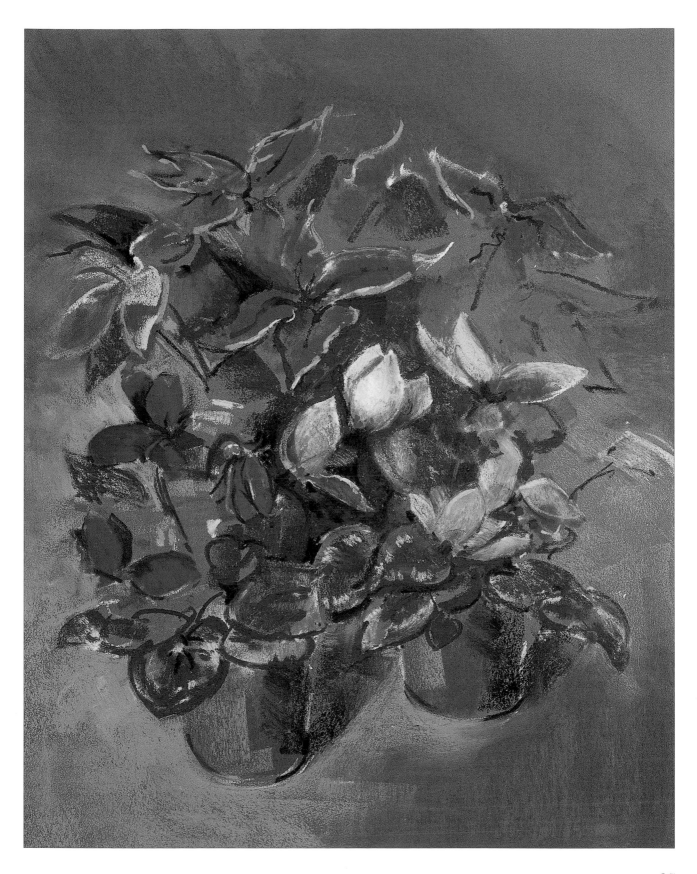

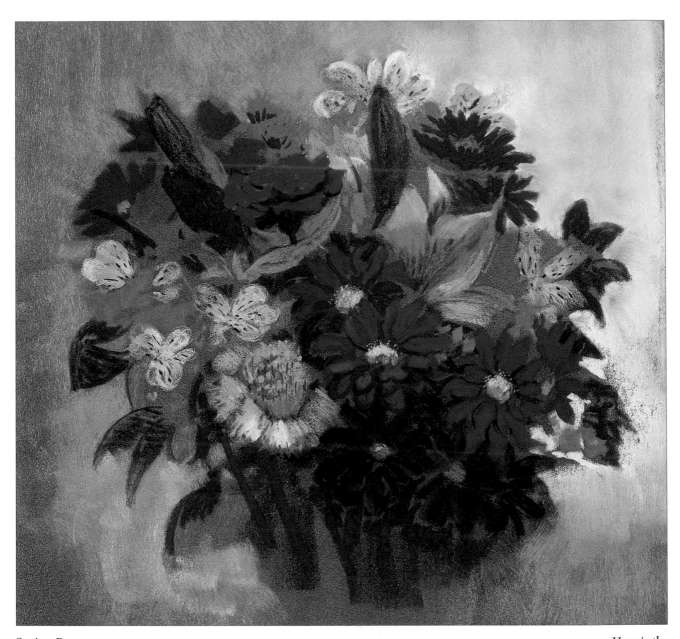

Spring Bouquet

As soon as I saw this bouquet I wanted to use blue paper to
balance its vibrant, hot colours with coolness. I chose dark
blue so I could accentuate a full range of lights and darks. The
flowers had more than enough contrasts and complications, so
I faded out the subject at the stems: trying to paint vases can
detract from the flowers. The solid flower shapes were blocked
in boldly with the main flower colour, then glazed with a much
lighter touch to add light, shadow, and adjust the colour. The
background was blocked in boldly where the dark blue was
too strong, then faded out by glazing lightly towards the outer
edges to merge into the paper colour.

Size: 310 x 310mm (12¼ x 12¼ in)

Hyacinths

The picture (right) in dry pastel on pastel card shows how a
limited palette – just lilacs and greens – keeps the theme
simple. I blocked in the outer shape of the pot and plant,
then divided it into individual flower stems. The heads are
basically oval, so I created the 'bulk' form of each head first
using light and dark contrasts, then built up the stems,
including tonal values behind the plant to create atmosphere.
The pot was actually silver, but I kept the same palette colours
so there was unity between plant and pot. Finally, I broke
down the large flower heads, suggesting the individual 'star'
shapes of the florets, mainly on the front flower.

Size: 380 x 270mm (15 x 10¾ in)

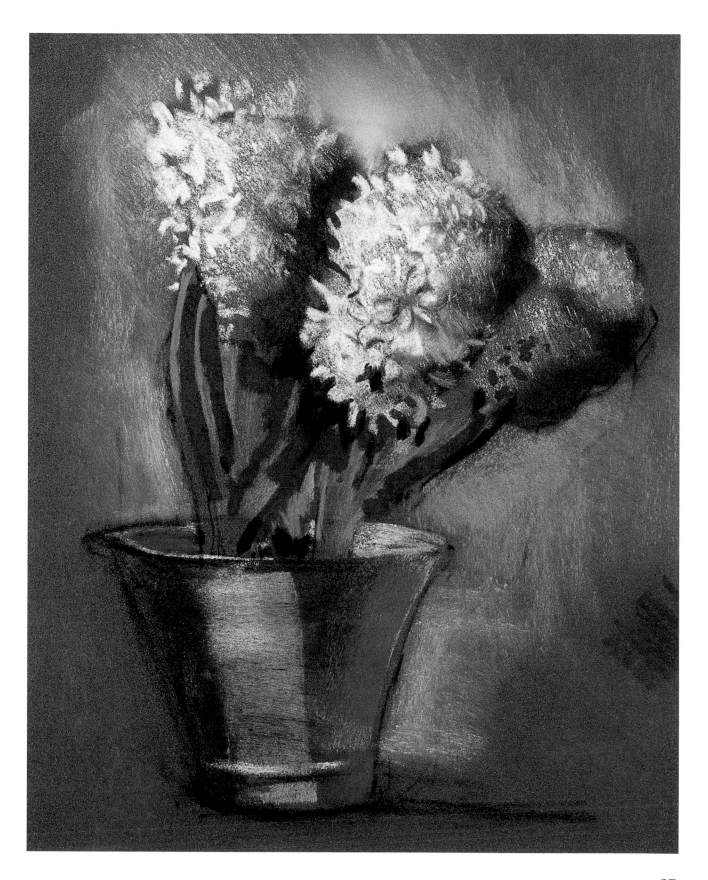

Photographs & sketches

Botanical painters, who have to study their subjects at close range, really have to work from life. Any artist will tell you that it is best to work from life if possible, but how often do you have the chance to paint in your garden? Even when you are visiting beautiful gardens, there is so much to see that there is often not much time to paint, and the weather does not often permit such luxuries. Besides, if the weather is that good, it is also good enough to catch up on gardening – as I often find when I go outdoors to sketch my roses! The advantages of using photographs are obvious, as long as we do not try to copy, which can be the biggest problem! With a looser style, good-quality photographs, backed up by sketches, are often easier to work from.

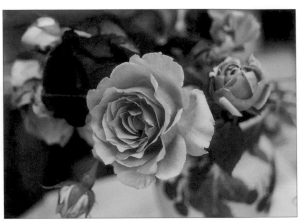

source photograph

The last roses

The roses, left, were painted entirely from a photograph, because they began to droop almost as soon as I brought them in. I started the painting from life, but took the photograph as soon as they began to droop and finished it later. I used part of the composition and did not attempt to copy the blooms or the detail slavishly.

Size: 290 x 240mm (11½ x 9½ in)

Daisies

For the picture opposite, I used a reference photograph along with a quick tonal sketch done at the same time. I like to do a preliminary tonal sketch if possible: it is invaluable not just for working out tones, but for trying out various compositions. My main concern in a study like this is to determine which shapes are light against dark, and which are dark against light; in other words, counter-change. I really believe that working this out first makes the process of completing any painting easier.

Size: 380 x 290mm (15 x 11½ in)

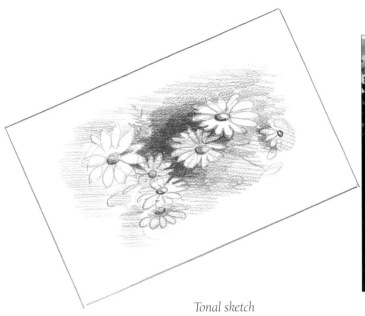

Tonal sketch

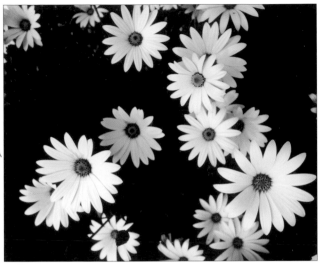

Source photograph

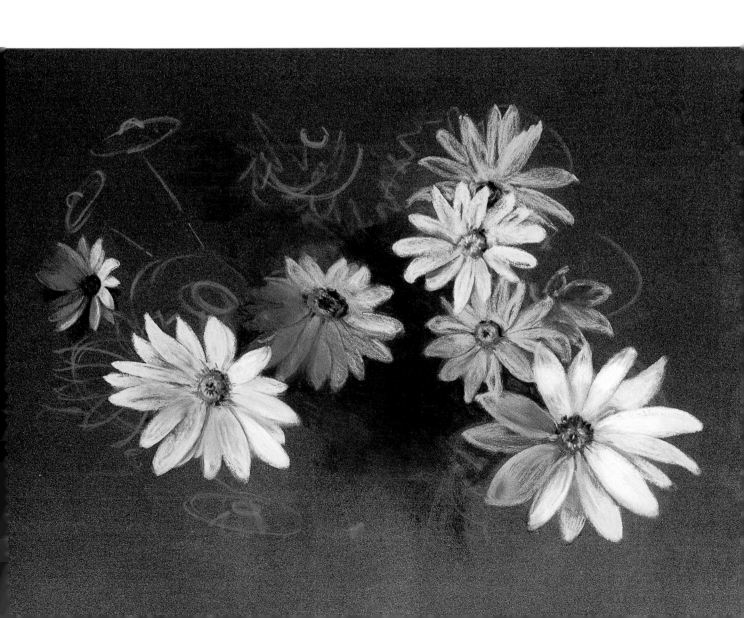

Garden

For this project, which is based on photographs of my neighbour's garden, the paper has been chosen to match the deep brown of the fence. Take care that you do not let the colour of the foliage overwhelm the colour of the paper. Remember that, for balance, you should pick a light and a dark tone of each colour in the painting. There are two different types of red in this painting, a bright, crimson red for the nasturtiums and a more muted burgundy red which is used on the fence. Each of these should be paired with a lighter tone. Bear in mind that when you are working quickly across the painting to put in the tones as I do, it is a great help if you can do it from life.

You will need
White cartridge paper
 for rough sketch
Pencil
Brown paper
Pastels

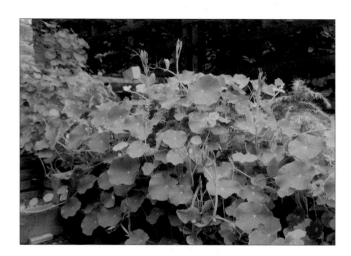

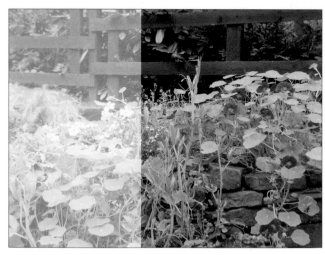

The photographs I used for reference. Only part of the bottom photograph was used.

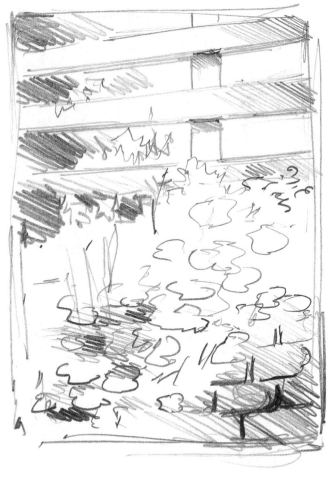

1. Referring to the source photographs, make a preliminary sketch.

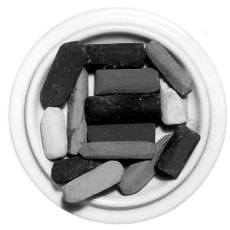

My palette for this project

2. Referring to the outline sketch, transfer the main shapes of your picture to the paper using yellow pastel.

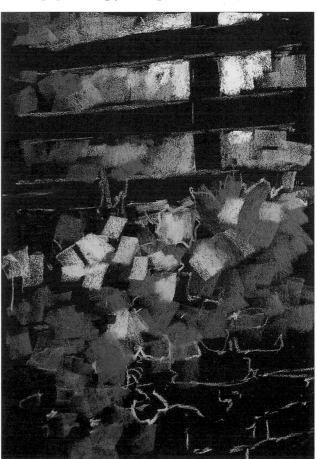

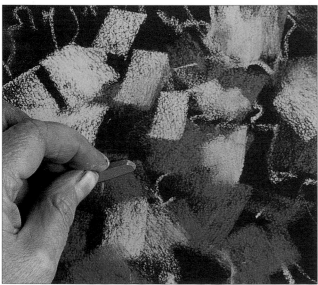

3. Using the pastels flat on the paper and two shades of green, roughly block in the mass of foliage. Scatter touches of green across the rest of the picture.

4. Add a range of blues, distributing the pale and dark areas evenly. To balance the composition, include a light and a dark variation of each blue.

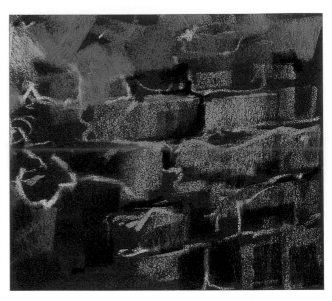

5. Put in the fence using light and dark red tones, holding the pastels flat to block in colour and using the ends to define the edges of the bars.

6. Block in the tones of the wall, using the same light and dark reds as were used for the fence.

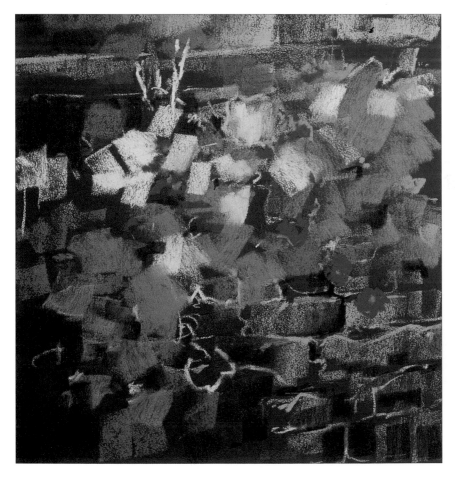

7. Referring to the source photograph for guidance but not being too pedantic, put in the bright reds of the flowers.

8. Go in on the centre of the picture and sharpen up the detail, using mid-green and blue.

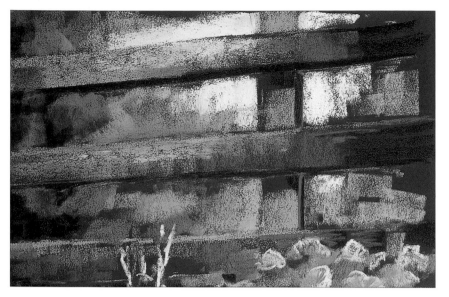

9. Warm the dark area of wood using pink pastel held flat against the paper. Add a touch of sky blue pastel to the fence to soften it and link the elements across the painting.

10. With blue pastel, glaze over the fence posts to take out the strong contrasts and untie the different areas.

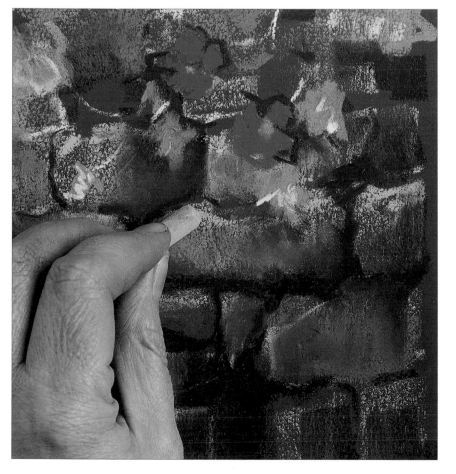

Glazing (see step 10) is making marks with the pastel held flat, working lightly. This allows one colour to be dragged over another to create a colour mix.

11. Use a little brown to tone down the blue on the wall. Blend the colour in by rubbing gently with your fingertips. Using the same brown to sharpen up the detail on the wall.

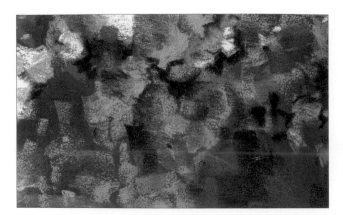

12. Rub dark blue pastel across the lower left corner of the picture to glaze across the foliage and pull the different elements together.

13. Go in on the centre of your picture and sharpen up the detail where necessary.

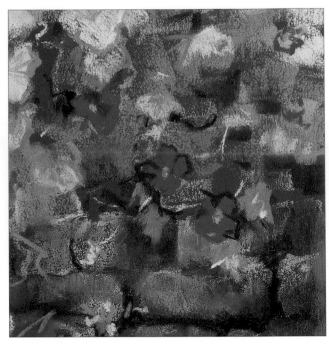

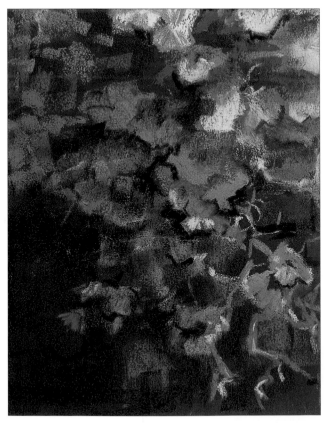

14. Add a few hints of dark red to the bottom left-hand corner to suggest flowers nestling in foliage. Glaze the area with a mid-toned pastel.

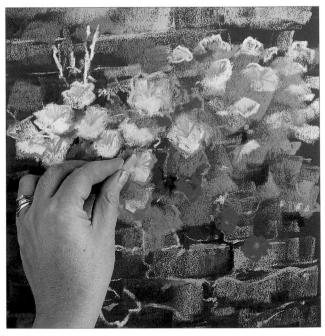

15. Stand back from your picture and make the final adjustments. The massed foliage looks too busy in places so use a mid-toned green to tone it down. The top left-hand corner has not been touched since it was first blocked in.

Opposite: the finished picture

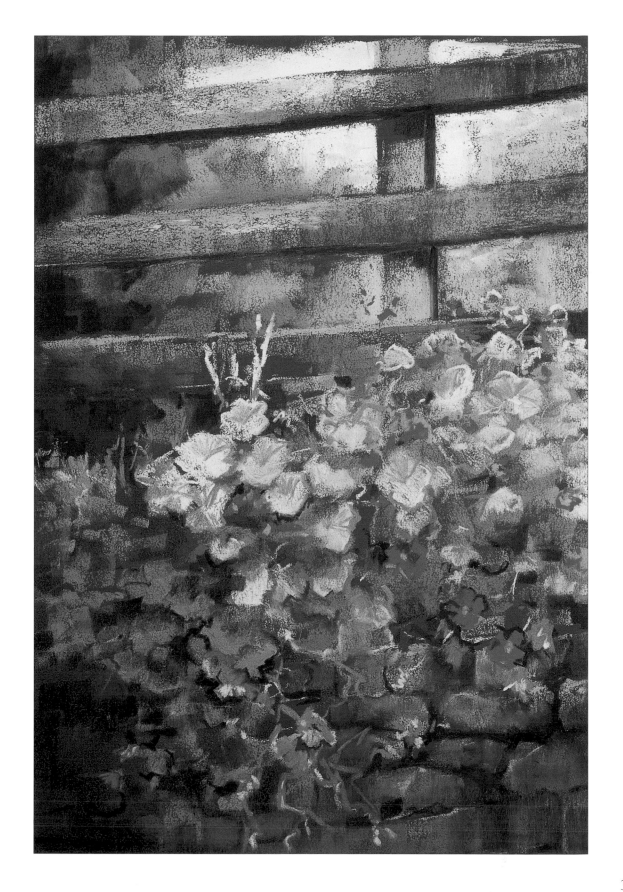

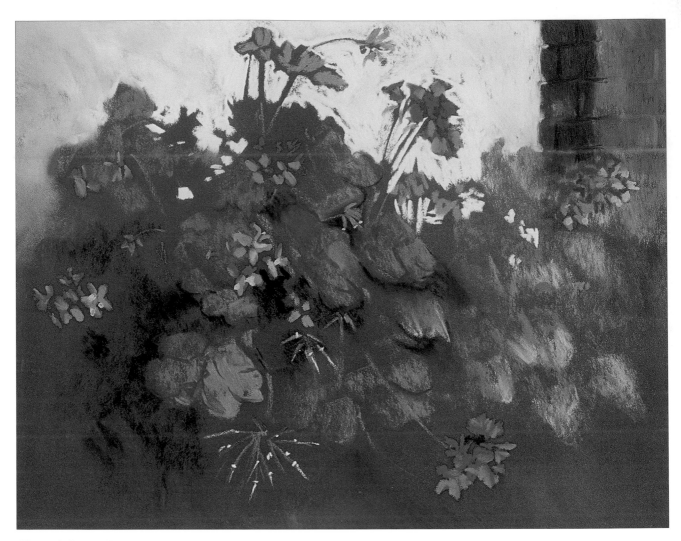

Cipressini geraniums

The stunning mass of geranium leaves and bright pink flower heads against a sunny background attracted me to the dark green sandpaper, which allows the foliage to 'disappear' into the paper colour. In contrast, impact was created by blocking in the sunshine behind the subject, making the negative shapes of individual leaves stand out. The pink flowers were then placed, using a soft, bright shade in easy directional strokes to indicate petals (see Playing with Pastels, page 16). A few dashes for seed heads and highlights on the flowers were all that was needed to suggest detail.

Size: 230 x 305mm (9 x 12in)

Delphiniums

Counter-change was a particularly strong theme to this subject, and the reason it inspired me to paint, glimpsing the spectacular delphinium against the strong dark rich greens of the Scots pine trees in my garden. I placed myself particularly to view the light shape of the flower against the dark tree, and used the feathery effect of the surrounding foliage to soften the composition and break up the shapes towards the outer edges.

Size: 380 x 270mm (15 x 10¾ in)

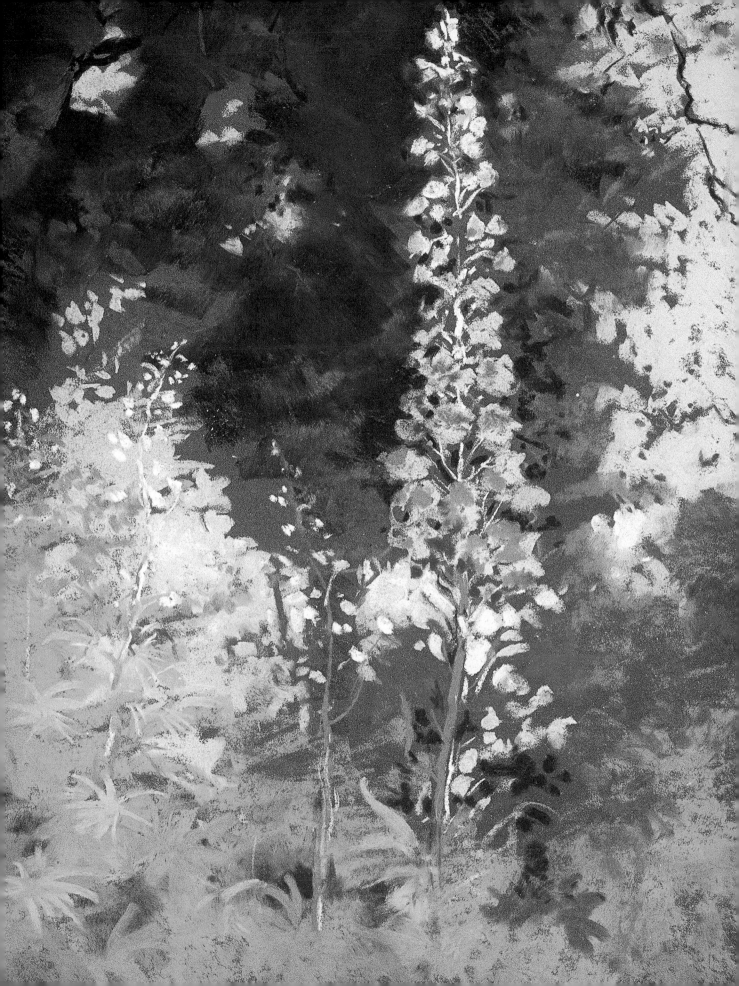

Adding water to pastels

To add or not to add: that is the question! Some subjects, particularly flowers, and usually those traditionally painted in watercolour, lend themselves to the addition of water. It is fun to use watercolour techniques, whether for the ethereal delicacy of roses, or for solid, vibrant colour like petunias or geraniums. You also have to decide whether to use 'wet' water or 'damp' water: when a wet brush is applied to pastel it dilutes the colour and creates washes, just as in traditional watercolour painting. If, however, a damp brush (with the water blotted out so it is just damp) is applied, the colour is intensified and can be used to create solid blocks of intense colour.

All pastels are made from pure pigment, but the binders added determine how effectively they can be diluted. Some cheaper brands are 'bolstered' with clay and kaolin so the proportion of pure pastel is lower, and solubility is affected. Expensive pastel ranges are generally softer, more crumbly, and far more receptive to wetting. Some will positively melt into pure colour. Experiment to discover whether pastels will dilute successfully. You should also test your paper to make sure it is receptive to water. Watercolour papers are ideal, but some pastel papers will buckle and some, like pastel card, may disintegrate. If you prefer to work on dark-toned papers, your colours must be opaque: mix body colour with white to create solid colour, as transparent colour will simply soak into the paper. I often block in the subject of a painting first using gouache or acrylic paint, before using pastel and water.

Rose sketch

If you use soft pastels on watercolour paper, there is no reason why you cannot simulate the techniques of watercolour painting and build it up in transparent layers, while retaining the white paper if the subject demands it. In this sketch I have built up the form of the peach flower by wetting each layer in turn, then applying more colour where I wanted a more intense tint. I applied fresh colour while the previous wash was still damp, creating a stronger, more vibrant effect which is similar to wet-in-wet watercolour techniques.

Petunias

The flower shapes were blocked in solidly with strong pink, tones added with paler pink, and the colour intensified using a damp brush. The green area is dry pastel applied with a lighter touch, showing the texture of the paper.

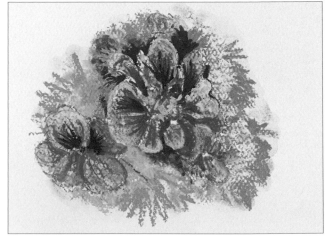

Italian pelargoniums

Similar marks on rough watercolour paper show how the effect can change with different paper types. Added water creates a denser, more painterly effect.

Mixed media

If pastel is simply blocked on to paper then diluted with water, it is technically still pure pastel. If you under-paint, or add gouache, watercolour, or acrylic paint, your work becomes mixed media.

With pure pastel, layers of pastel can be alternated with layers of washes of water, diluting and building up colour, from light to dark. Each layer can be added to when dry, although I have achieved some interesting effects by putting dry pastel on top of damp pastel. The main feature of this practice is that pastel diluted with water becomes paint and therefore does not smudge. This means you do not need fixative to make your painting permanent – though I never use fixative! Watercolour washes can be used to produce dramatic backgrounds to pastel flowers. These can be put down first and the pastels worked in while they are still wet (see *Lilies*, right). They can also be applied after the pastels (see *Gladioli*, below).

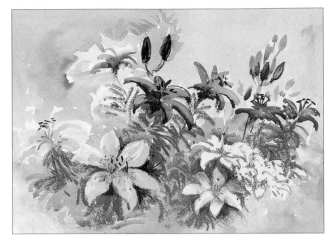

Lilies

I had only ten minutes to capture these flowers, so I put wet washes of pink and green watercolour over the page, then worked the pastel lilies into the damp colour. The white lilies were painted in negative by retaining the white paper, and the texture of the foliage was suggested by building it up with dry green pastel.

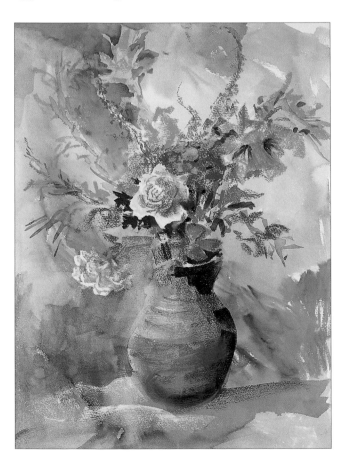

Under-painting

With gouache, I prefer to under-paint. I sketch in the outline of my subject with a faint watery solution of colour, then block in tonal opposites with solid gouache. When I have divided the composition into the main light and dark proportions, I develop the rest of it with pastel, dampening it in areas to solidify or intensify colour. Acrylic paint is also ideal for under-painting, as it dries very quickly leaving a flat colour to work on top of. It is permanent when dry, so the pastels can be wetted to create further layers and glazes. I use acrylics thinly, adding white to create opacity, and ensuring there is sufficient 'tooth' left on the paper to grip the pastel on top.

Gladioli

This demonstration shows how watercolour washes can be applied around blocks of pastel, to create background which surrounds and interacts with the subject. The top flower has been painted with negative shapes in watercolour, whereas the right-hand gladiolus has been applied on top of watercolour background washes to create depth. Although loose and sketchy, this work has plenty of action and atmosphere.

Size: 510 x 360mm (20 x 14¼ in)

Rose bouquet

For this demonstration, I have deliberately chosen a soft, pale-coloured paper to enhance the delicacy of the roses, and to help to intensify the vibrant colour of the main rose, on which water is used to strengthen the colour. I want to keep the overall impression very soft with the roses merging into the pale blue paper, so I will retain a soft edge to the outer roses.

You will need
White paper
Pale grey paper
Soft pencil - 8B
Pastels

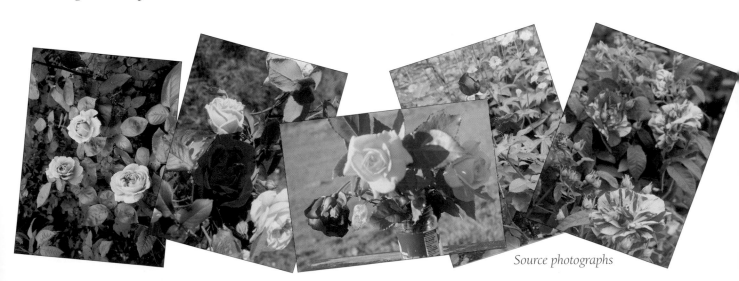

1t may be useful to secure the source sketch and photographs around the edge of the easel as you work for reference.

1. Referring to the source photographs, make a rough sketch plan.

Source photographs

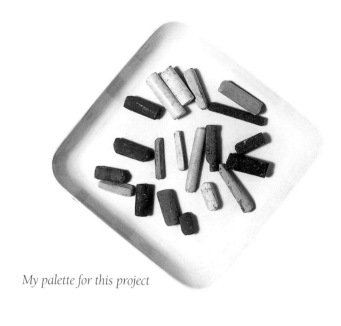

My palette for this project

2. Sketch in the outlines of your composition using white pastel.

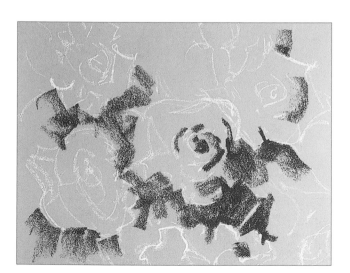

3. Put in some dark tones using dark blue/grey.

4. Put in the mid-green tones, choosing the shade by trial and error and remembering that on pale paper colours can look far darker.

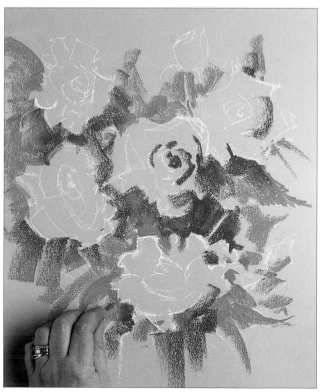

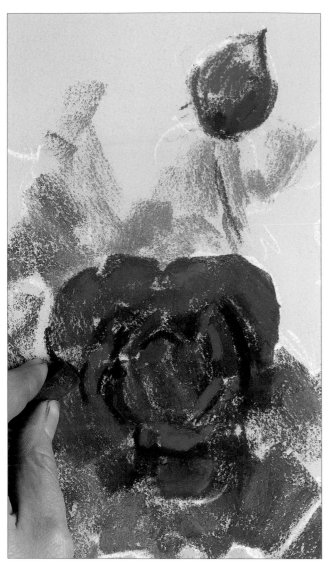

5. Using dark and mid tones of red and pinky-red, block and sketch in the details of the Etoile de Hollande rose.

6. Using pale and deep shades of pink, place the colours for the two pink Penny Lane roses on the left, then add yellow to tie them in with the other roses across the page.

7. Put in the single yellow rose using bright and pale yellow tones. Add touches of red to tie it in with the other flowers across the painting.

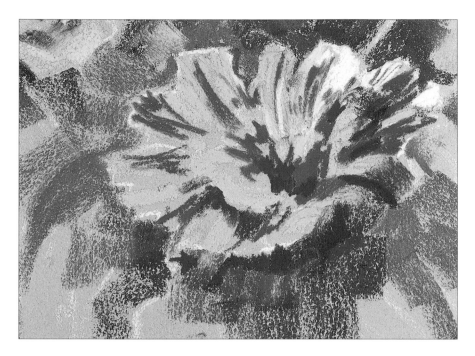

8. Add the Rosa Mundi in the foreground using two shades of pink pastel. Add red to link it with the other roses, and white highlights. Add the yellow centre and accents, which will link it with the single yellow rose.

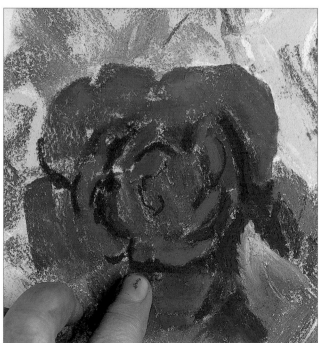

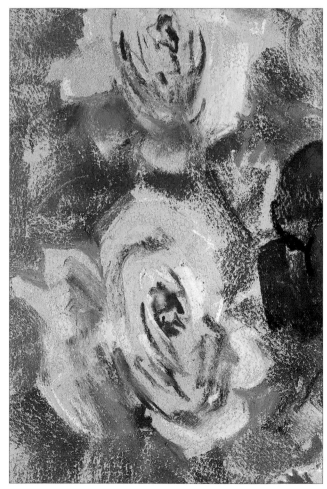

9. Add a little yellow to accent the foliage under the red rose. Put in some touches of red to suggest stems. Rub in some areas to soften the pastels.

10. Put in some blue-grey pastel, very similar in colour to the paper, to help to merge the pink roses into the shadows at the edges.

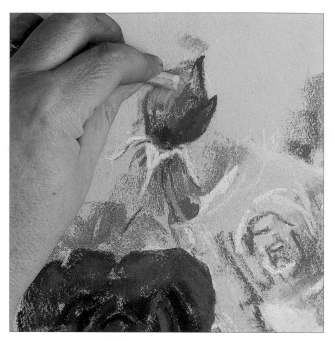

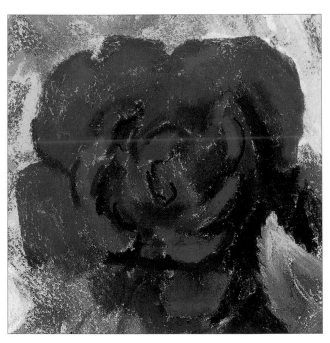

11. Put in a little blue-grey pastel to merge and define the rosebud at the top of the painting.

12. Work over the central rose, thickening up the colour to eradicate the grain of the paper.

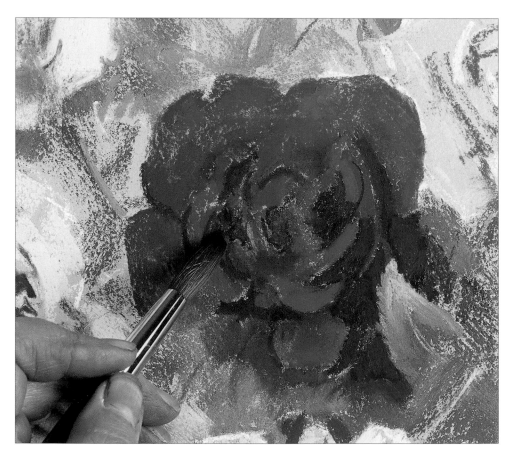

13. Use a paintbrush to add a little water to the rose in the centre of the painting. This will solidify the colour and provide an interesting contrast with the other areas which are grainy. Use a cloth to take off any excess water.

Right: the finished painting

44

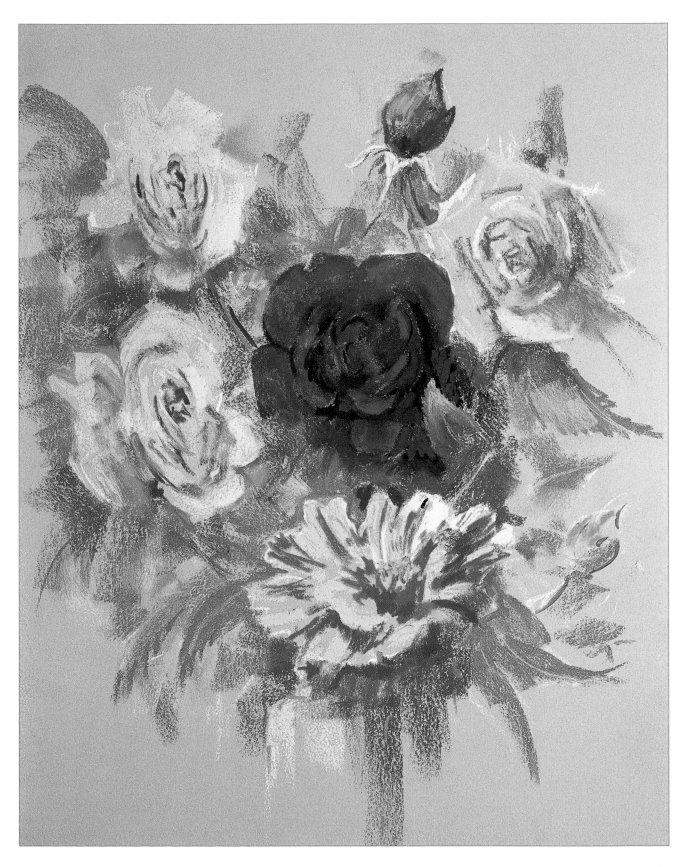

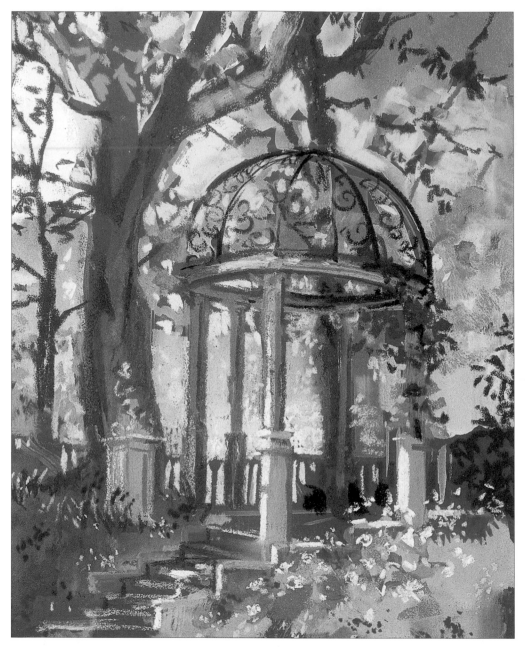

Italian Garden
Gouache under-painting and pastel

A large, well-stocked garden can be overwhelming to paint. This example shows how to select a small area with a feature i.e. a pergola and concentrate on the play of light and dark. I used dark paper (blue) and blocked in the lightest tones with pale tints of gouache, using plenty of white for body colour. The flower details are an impression rather than a description.

Size: 370 x 260mm (14½ x10¼ in)

Opposite:
Hollyhocks at Heale House

Working on rough watercolour paper, I created a background of colour and texture for the beautiful lemon hollyhocks. I built up from thin pastels washed with water, to thicker, more impasto techniques, therefore working from thin to thick paint, and from background to foreground. The hollyhocks were strengthened against the dark window which was blended to a smooth finish.

Size: 430 x 305mm (17in x 12in)

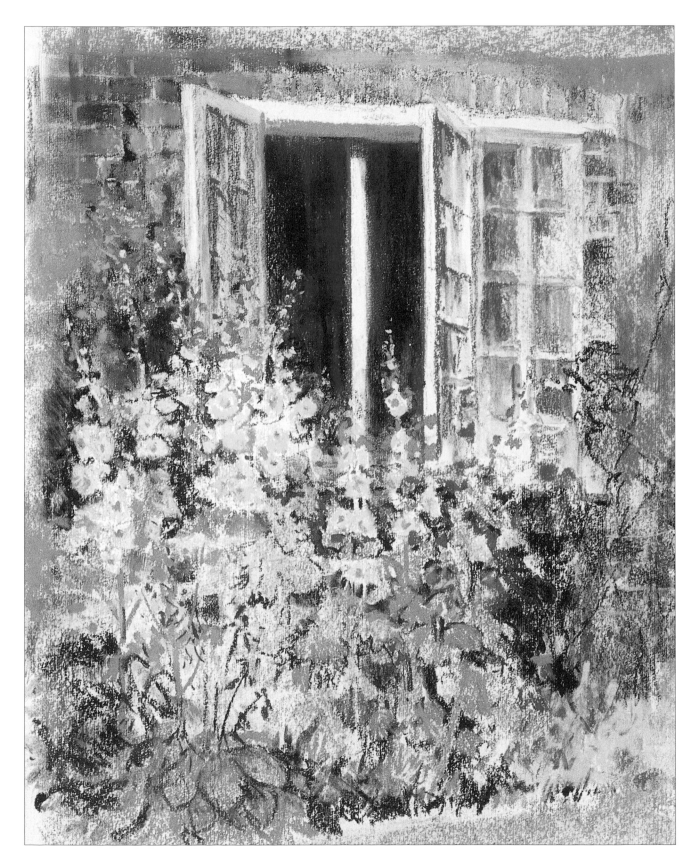

Index

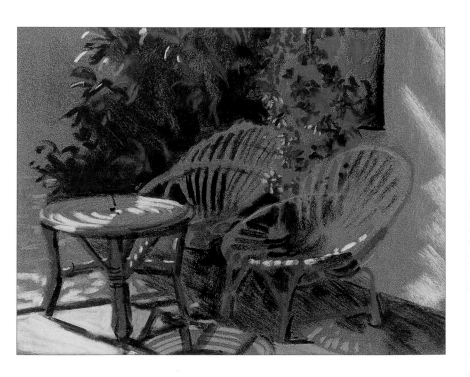

Cipressini patio

Though flowers and gardens can seem daunting and complicated to paint, sometimes a shady corner with just a suggestion of flowers is sufficient to capture the essence of the place. Dry pastel on pastel card (which does not take water at all) is applied with simple, bold strokes to create patterns of light and dark.

Size: 305 x 230mm (12 x 9in)